W9-DCD-516

ART NOUVEAU ANIMAL DESIGNS AND PATTERNS

60 Plates in Full Color

M. P. Verneuil

DOVER PUBLICATIONS, INC.

NEW YORK

Copyright © 1992 by Dover Publications, Inc.
All rights reserved under Pan American and International Copyright
Conventions.

Published in Canada by General Publishing Company, Ltd., 30 Lesmill Road,
Don Mills, Toronto, Ontario.
Published in the United Kingdom by Constable and Company, Ltd., 3 The
Lanchesters, 162–164 Fulham Palace Road, London W6 9ER.

This Dover edition, first published in 1992, contains all 60 plates originally
published in *L'animal dans la décoration*, Librairie Centrale des Beaux-Arts, Paris,
c. 1897.

DOVER *Pictorial Archive* SERIES

This book belongs to the Dover Pictorial Archive Series. You may use the
designs and illustrations for graphics and crafts applications, free and without
special permission, provided that you include no more than four in the same
publication or project. (For permission for additional use, please write to Dover
Publications, Inc., 31 East 2nd Street, Mineola, N.Y. 11501.)

However, republication or reproduction of any illustration by any other graphic
service whether it be in a book or in any other design resource is strictly
prohibited.

Manufactured in the United States of America
Dover Publications, Inc., 31 East 2nd Street, Mineola, N.Y. 11501

Library of Congress Cataloging-in-Publication Data

Verneuil, M. P. (Maurice Pillard), 1869–
 [Animal dans la décoration. English]
 Art nouveau animal designs and patterns : 60 plates in full color / by M. P.
Verneuil.
 p. cm. — (Dover pictorial archive series)
 Translation of: L'animal dans la décoration.
 ISBN 0-486-27218-4 (pbk.)
 1. Decoration and ornament—Animal forms. 2. Decoration and
ornament—Art nouveau. I. Title. II. Series.
NK1555.V513 1992
745.4'441—dc20 92-13000
 CIP

PUBLISHER'S NOTE

The ornamental style known as Art Nouveau or Jugendstil flourished in Europe and then in the United States from about 1880 to 1910. As its name suggests, the movement conceived of itself as a radical break with the past, rejecting what it saw as the predominantly classical and conservative aesthetic approach to ornamentation in the second half of the nineteenth century. Art Nouveau's major influences included William Blake and William Morris, and, more generally, medieval and Far Eastern art. The new aesthetics called for a return to organic forms, and its style was characterized by sinuosity and asymmetry.

The present volume reproduces all 60 plates from M[aurice] P[illard] Verneuil's lithographed portfolio *L'animal dans la décoration* (circa 1897). The portfolio contained patterns oriented to a great variety of design applications, including textiles, ceramics, stained glass, wallpaper and stencils. The forms offered included borders, corners, vignettes and allover patterns. Verneuil's collection of plates was introduced by his teacher and mentor, Eugène Grasset, who argued passionately in the original introduction for a reevaluation of the status of the animal form in the aesthetics of ornamentation. He explains the exclusion of such creatures as rats, mice, lizards, frogs, grasshoppers, snails and bats as a result of the tendency toward relief ornamentation, which, he argues, makes the majority of animals seem repulsive rather than attractive. Fully endorsing Verneuil's efforts, Grasset argues that the natural object should be taken by the designer only as a point of departure, a motif that can then be subjected to free composition. In Verneuil's designs he sees a movement in this direction and a successful rebuttal of absolute realism.

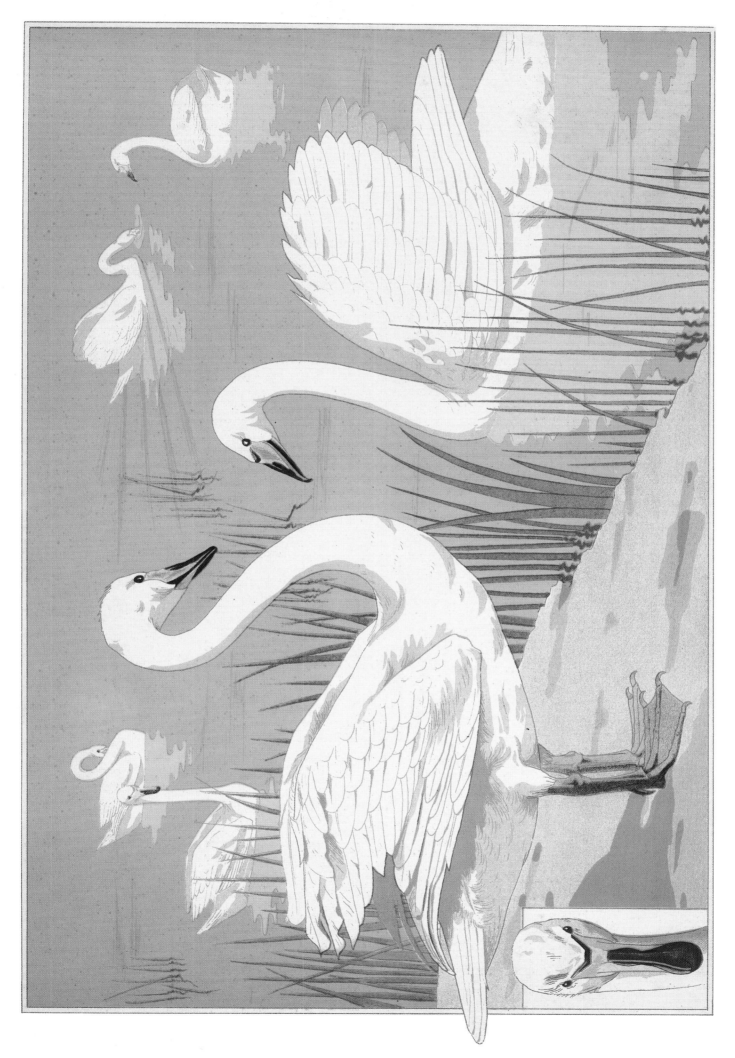

1. Wild swans.

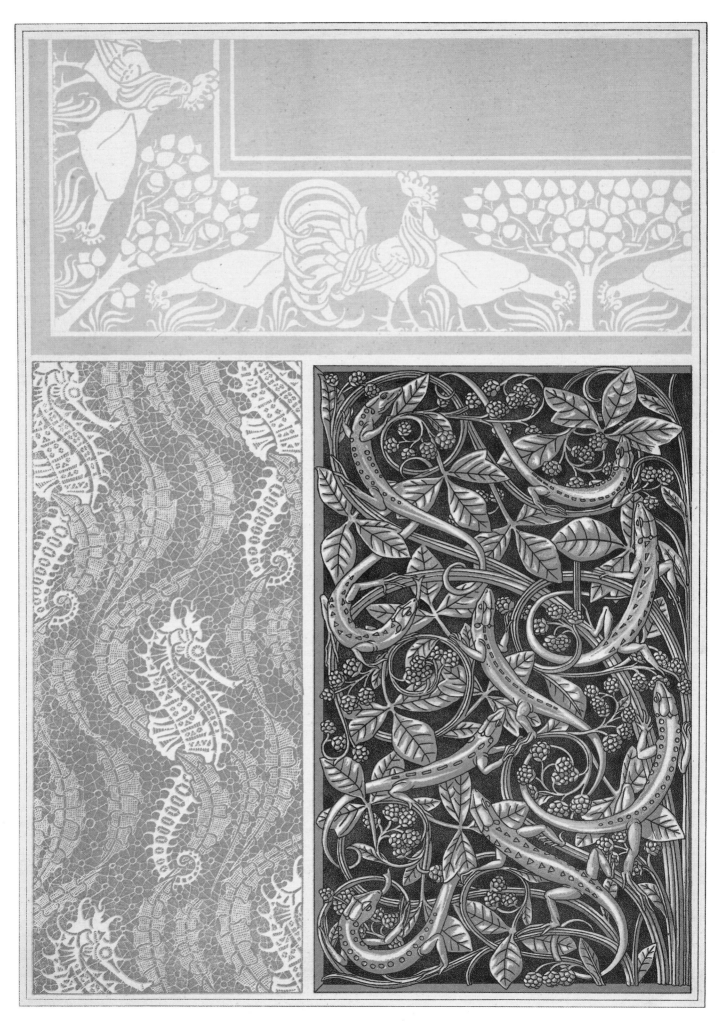

2. Roosters and hens; sea horses and seaweed; lizards and blackberry bushes.

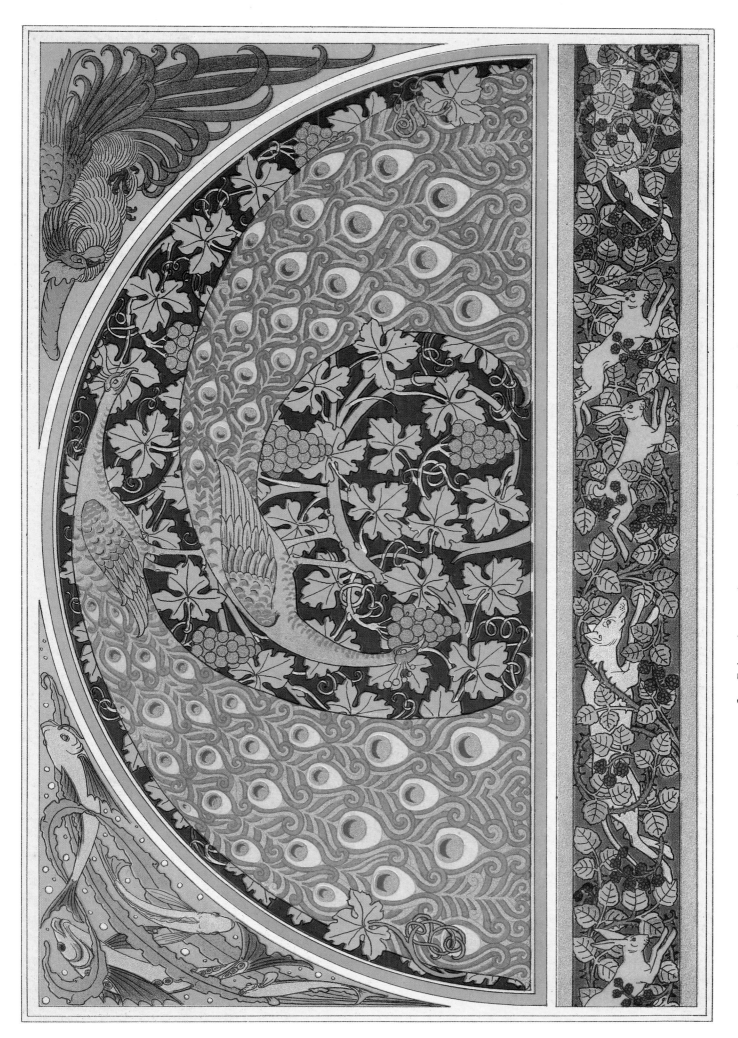

3. Fish and seaweed; rooster; peacocks and vine; hares, dogs and blackberry bushes.

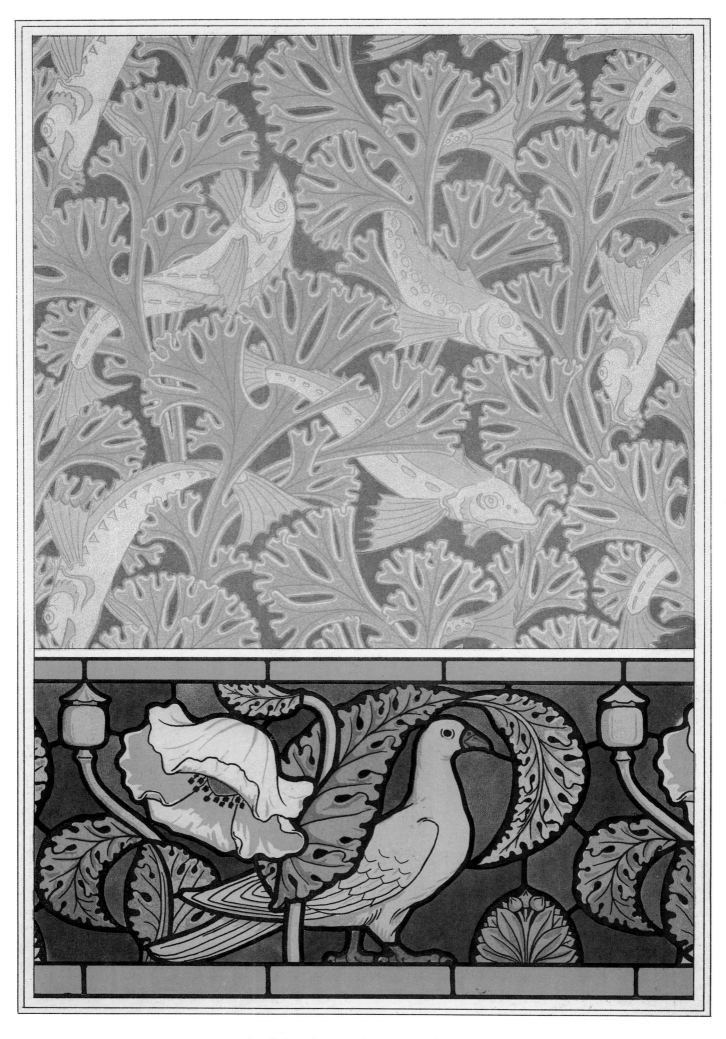

4. Fish and seaweed; pigeon and poppies.

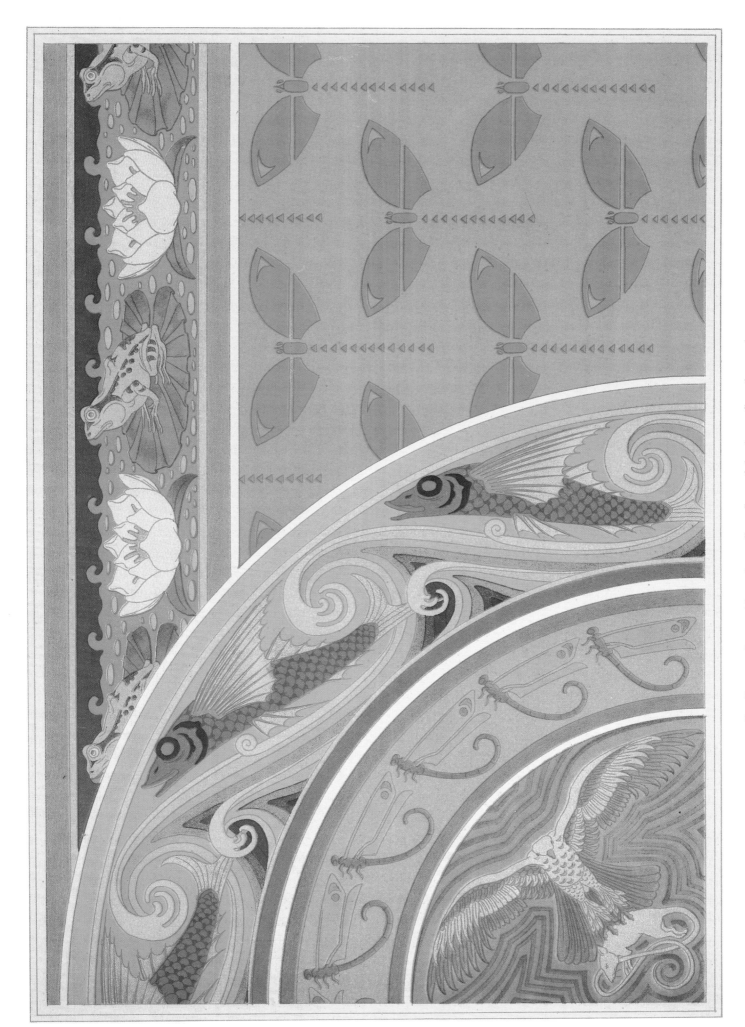

5. Frogs and water lilies; dragonflies; flying fish; dragonflies; kite and rat.

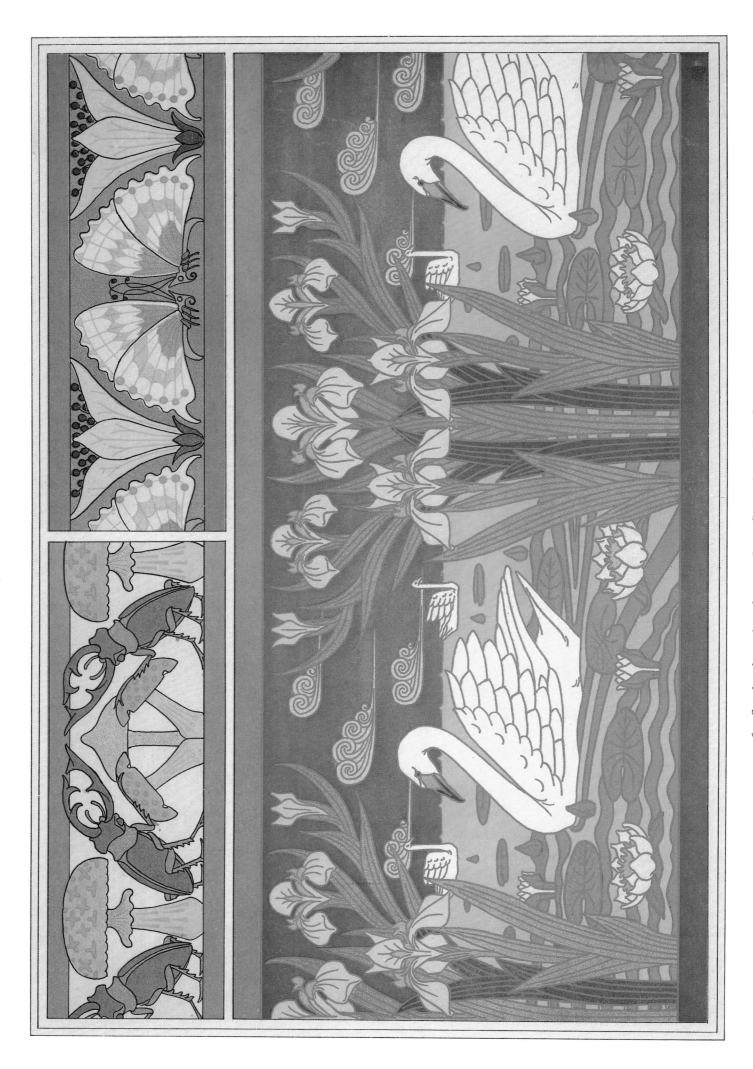

6. Stag beetles and mushrooms; butterflies and wood sorrel; swans, irises and water lilies.

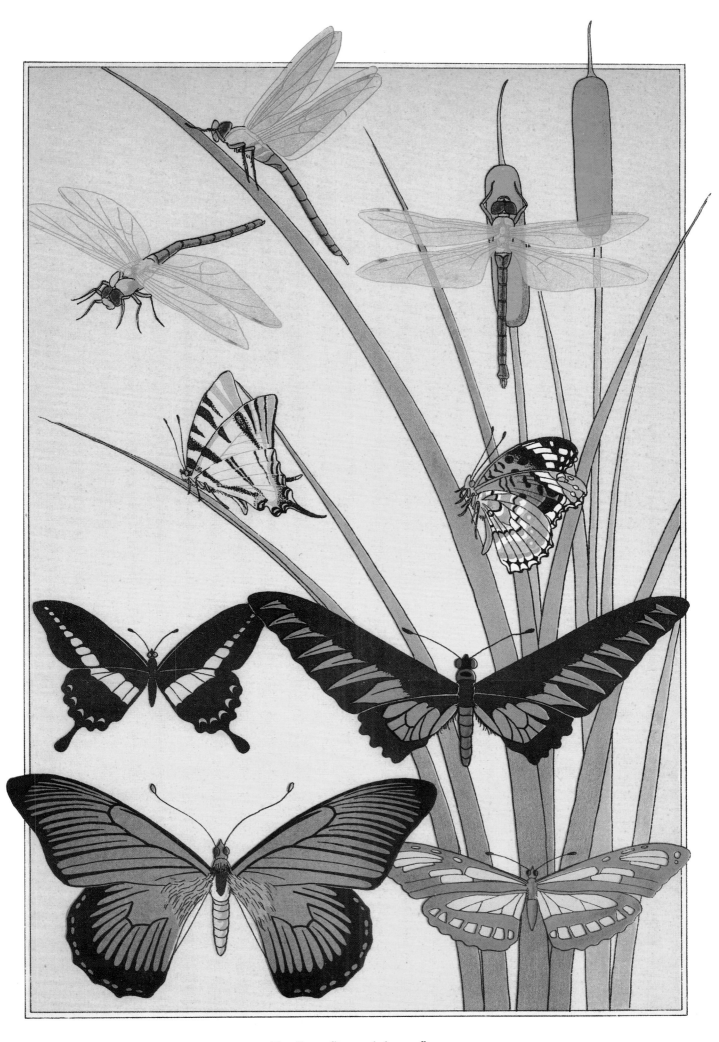

7. Butterflies and dragonflies.

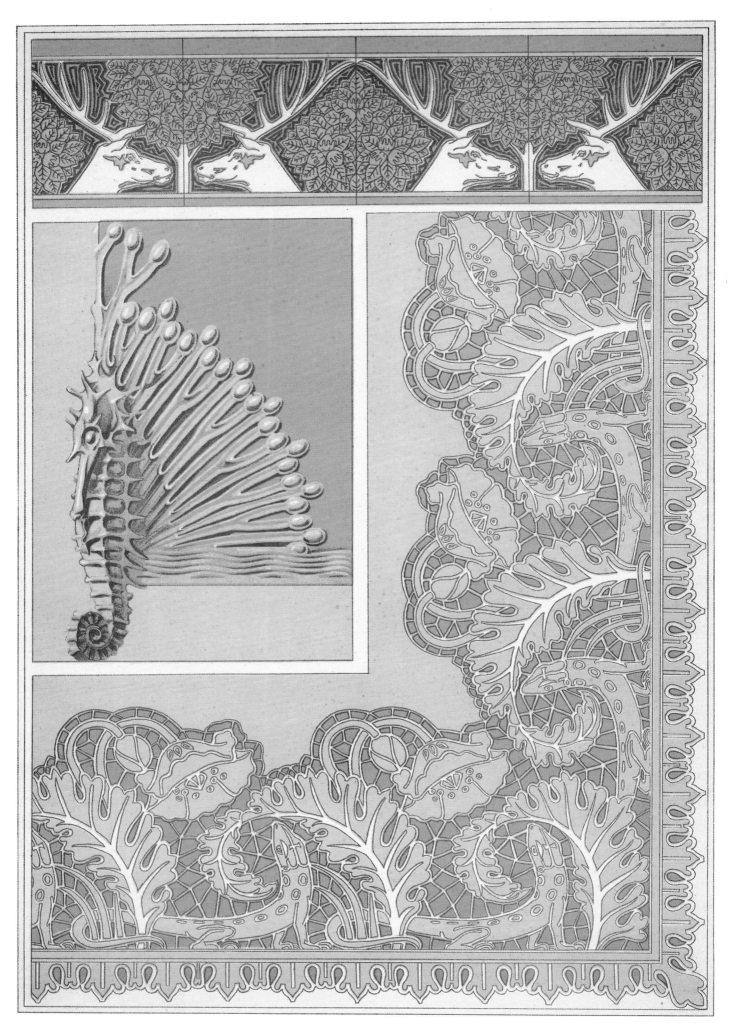

8. Stags and hazel trees; sea horse and seaweed; lizards and poppies.

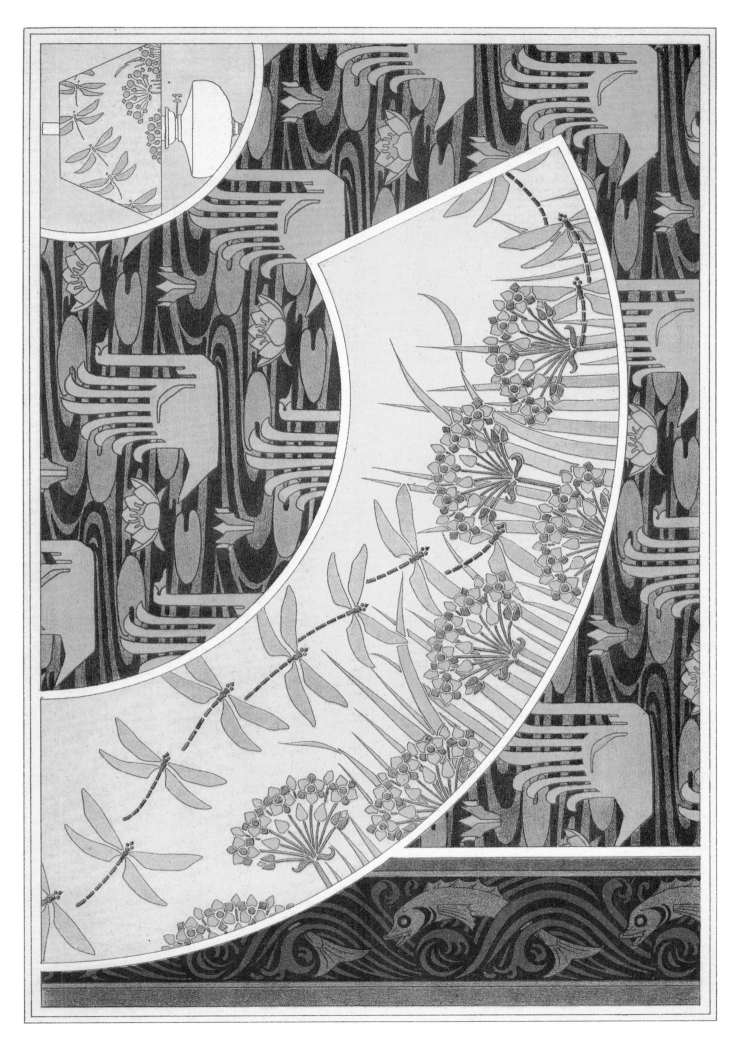

9. Fish, dragonflies and butomus; swans and water lilies.

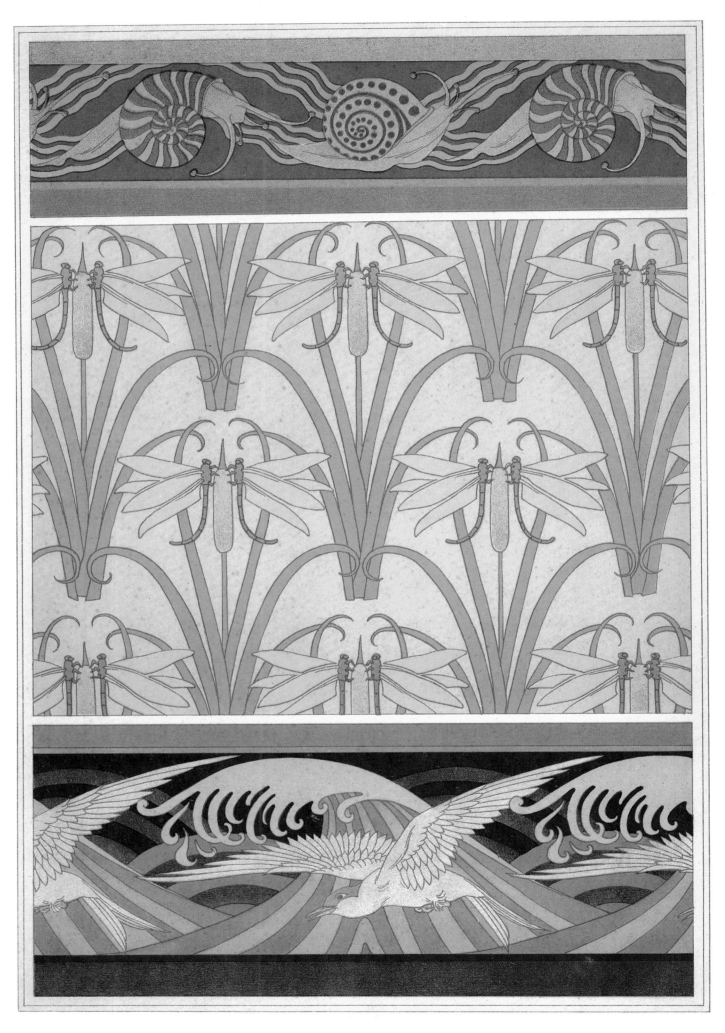

10. Snails; dragonflies and reeds; gulls.

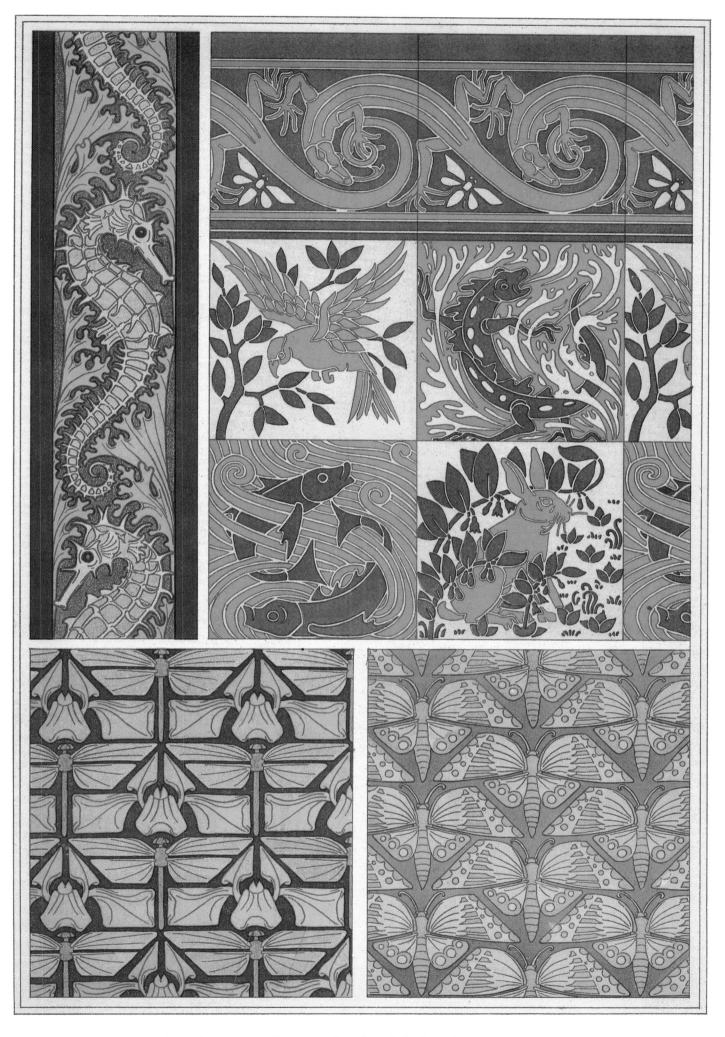

11. Sea horses and seaweed; lizards and the four elements; irises and
dragonflies; butterflies.

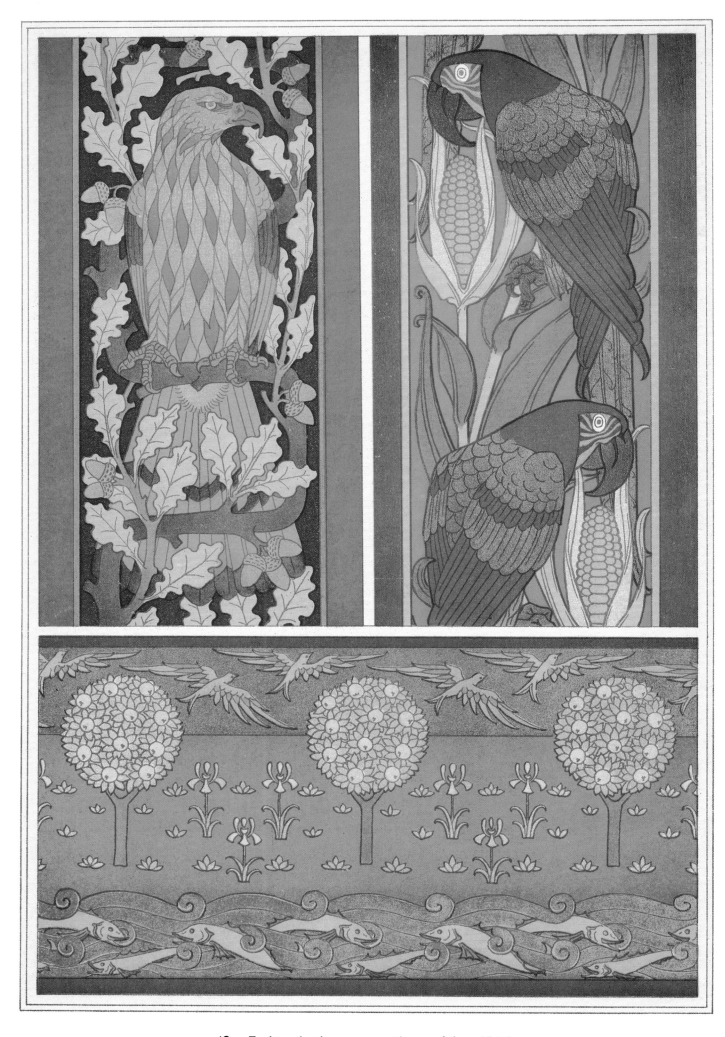

12. Eagle and oak; macaws and corn; fish and birds.

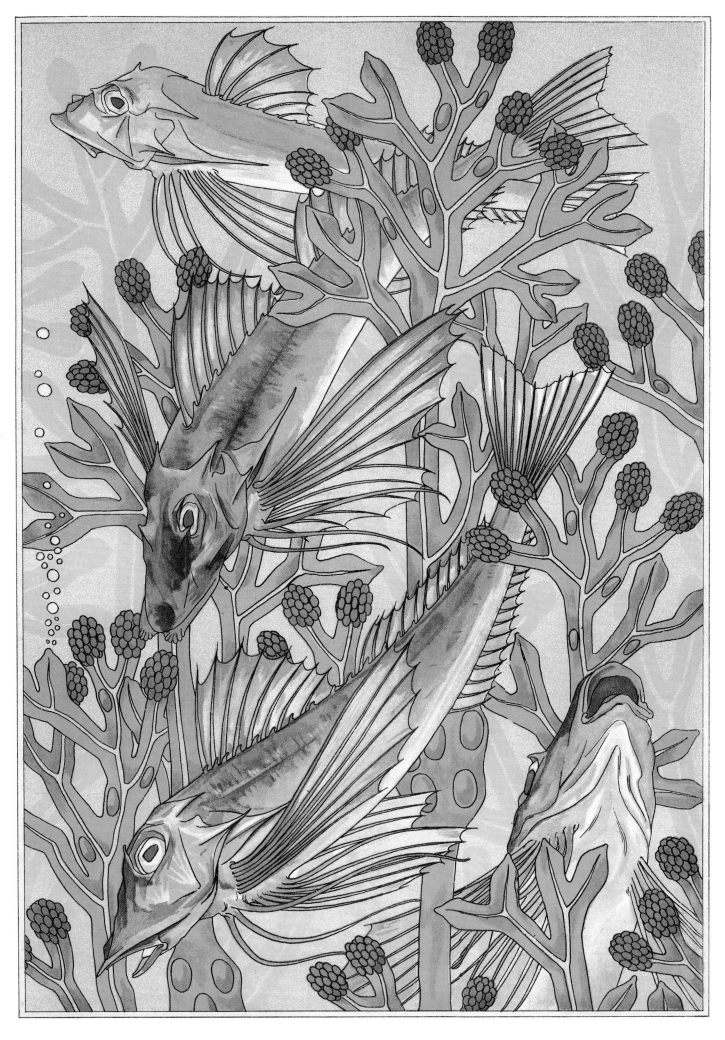

13. Red mullet.

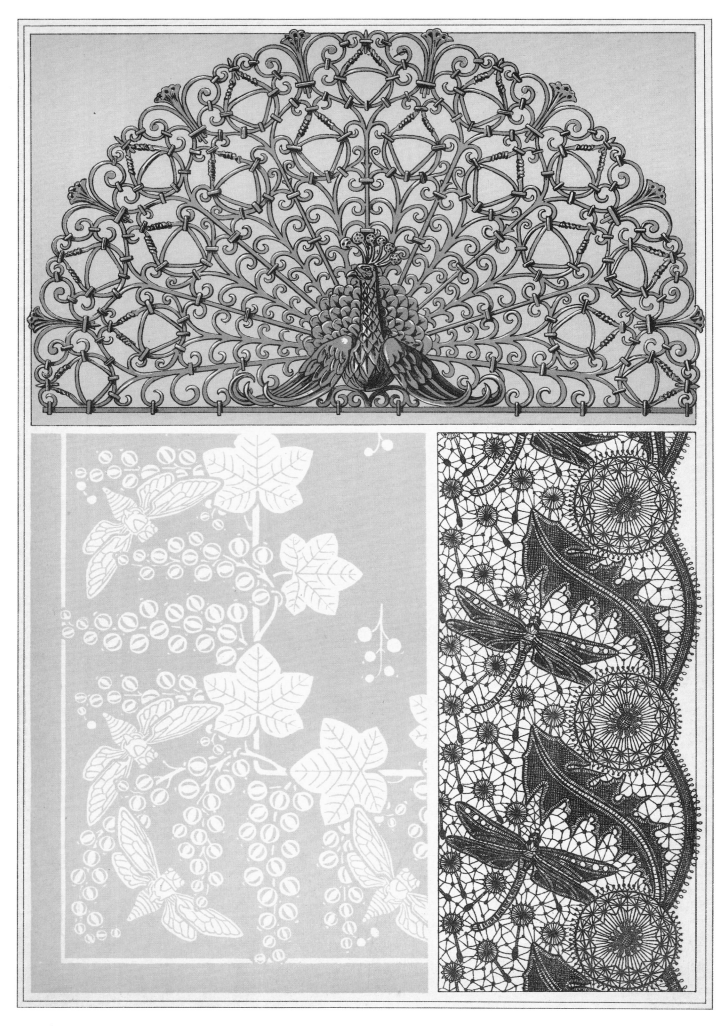

14. Peacock; cicadas and currant bush; dragonflies and dandelions.

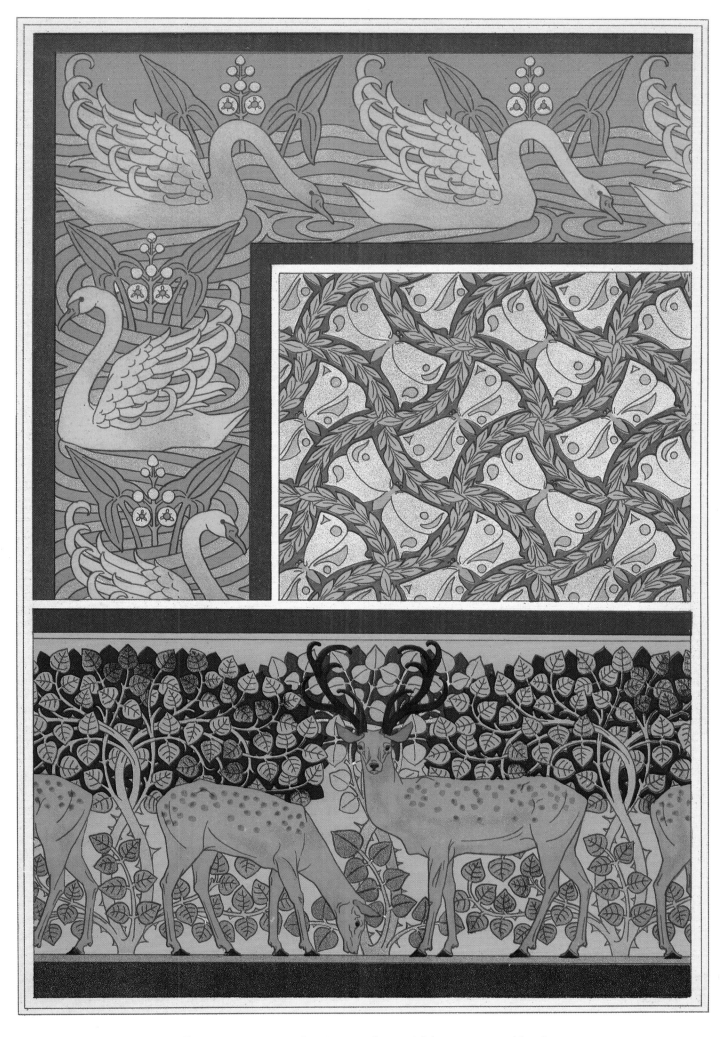

15. Swans and arrowhead; butterflies and foliage; stags and hinds.

16. Fish, cockatoos and lemons.

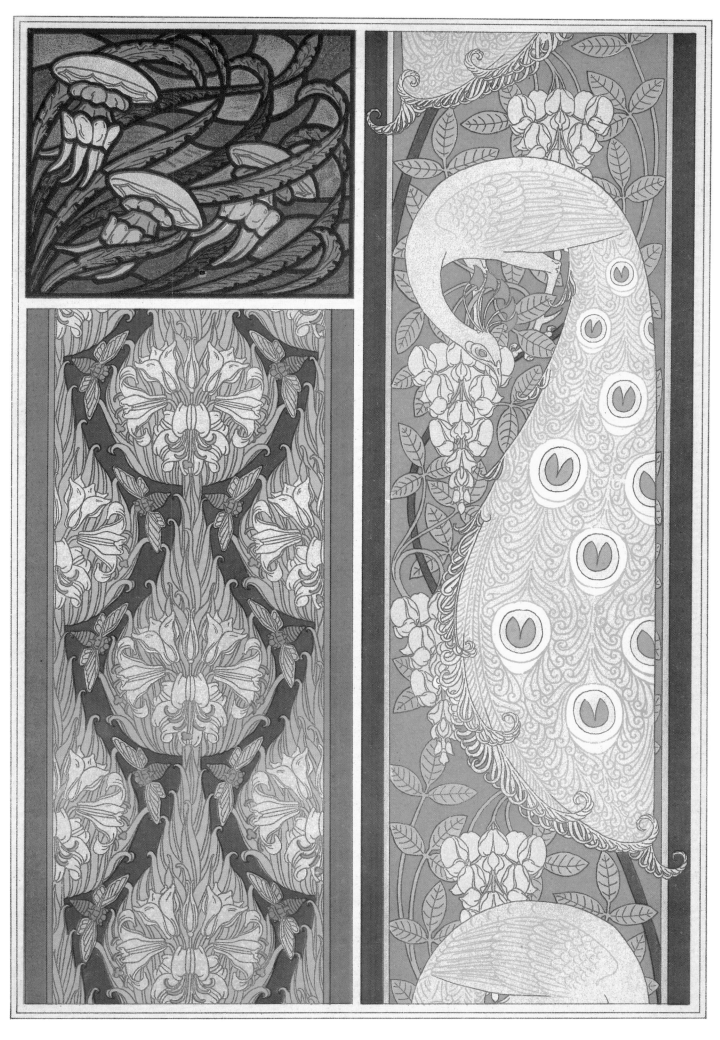

17. Jellyfish and seaweed; cicadas and lilies; peacocks and laburnum.

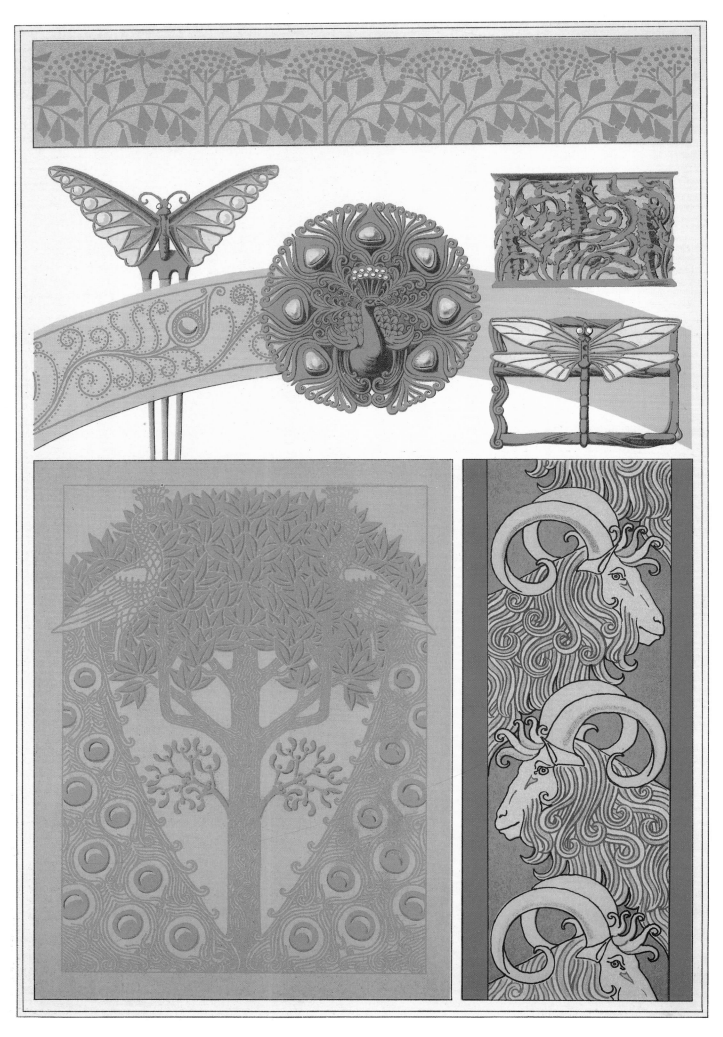

18. Dragonflies; butterfly, peacock, sea horses and dragonfly; peacocks; goats.

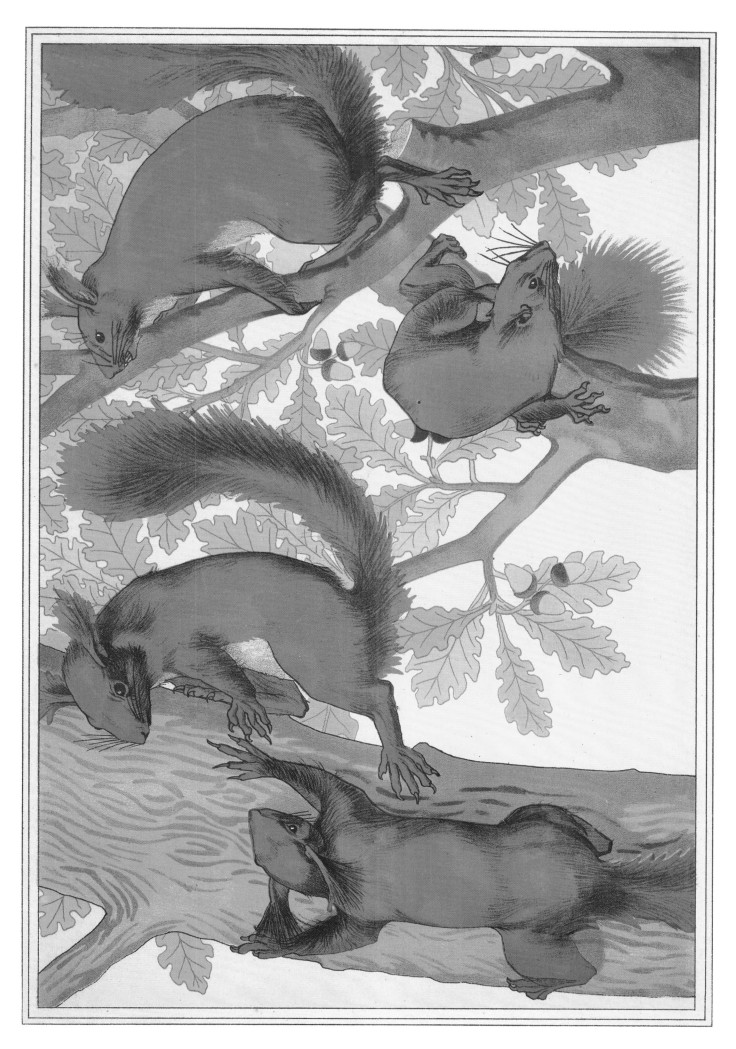

19. Squirrels.

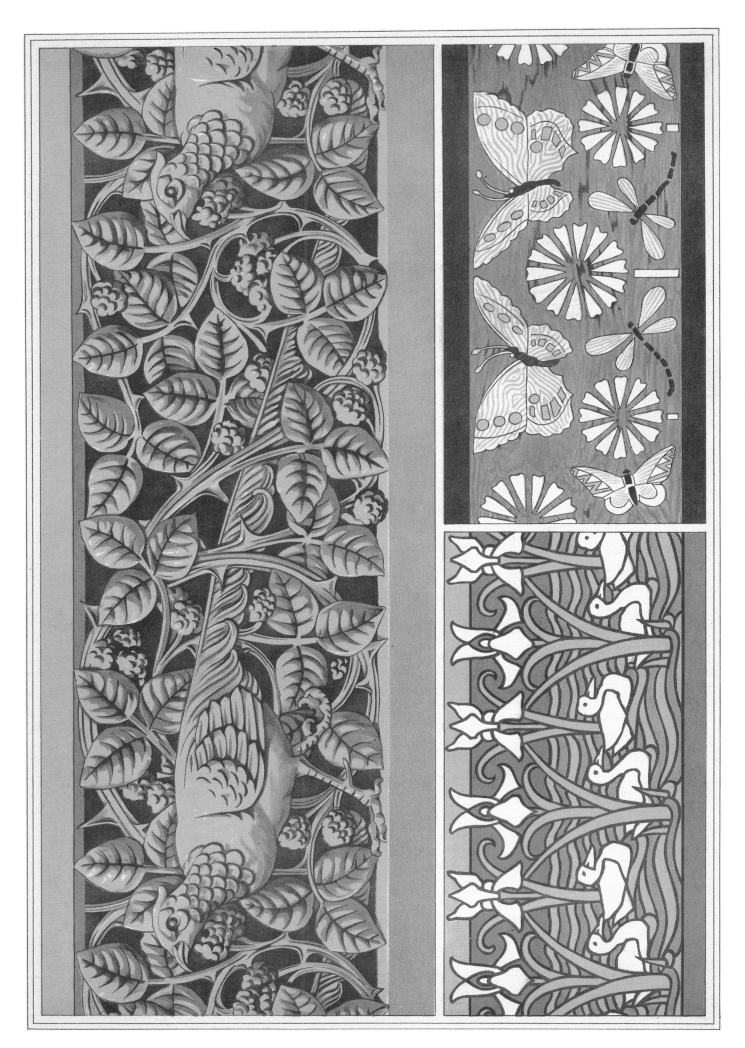

20. Pheasants and blackberry bushes; ducks and irises; butterflies and dragonflies.

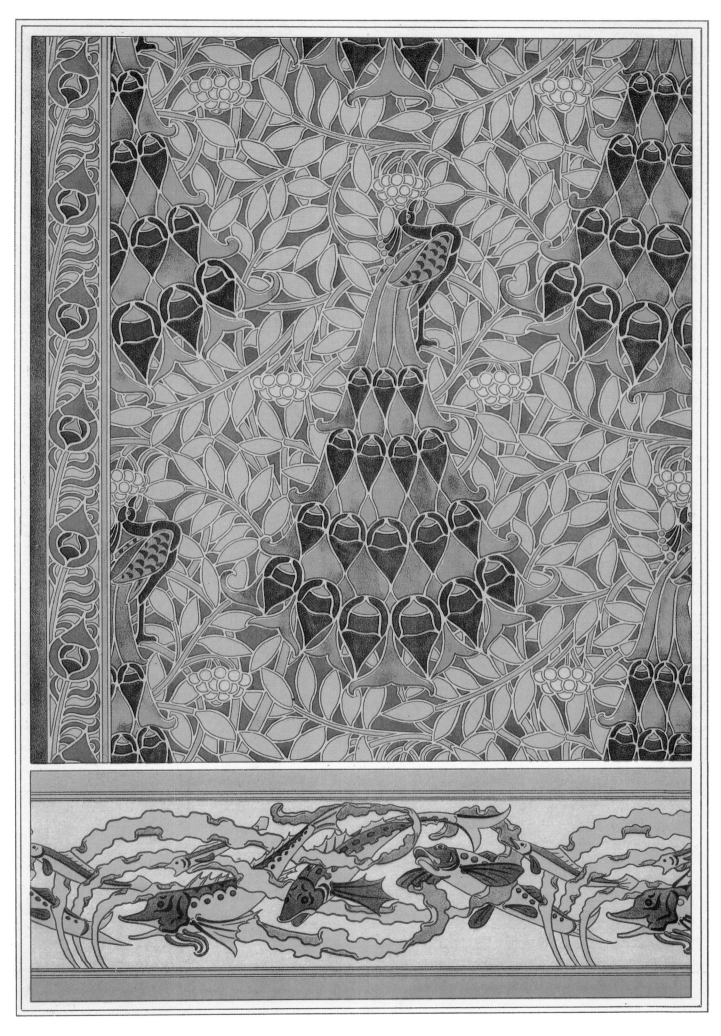

21. Peacocks and sorbs; fish and seaweed.

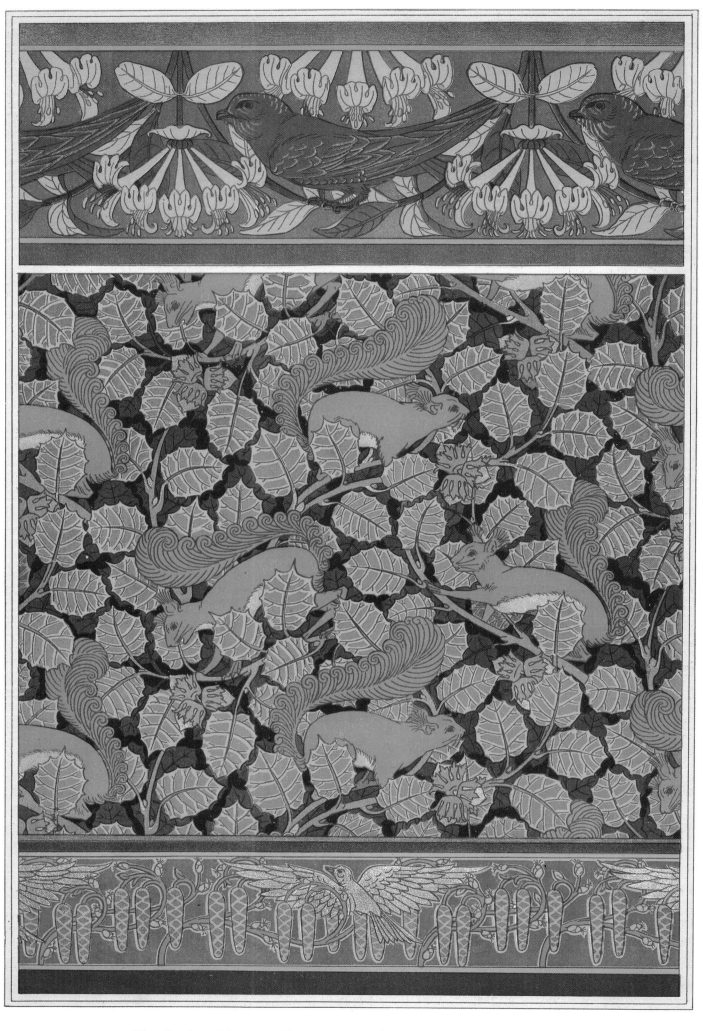

22. Swifts and honeysuckle; squirrels and hazel; birds and flowering hazel.

23. Crows, cicadas and thistles.

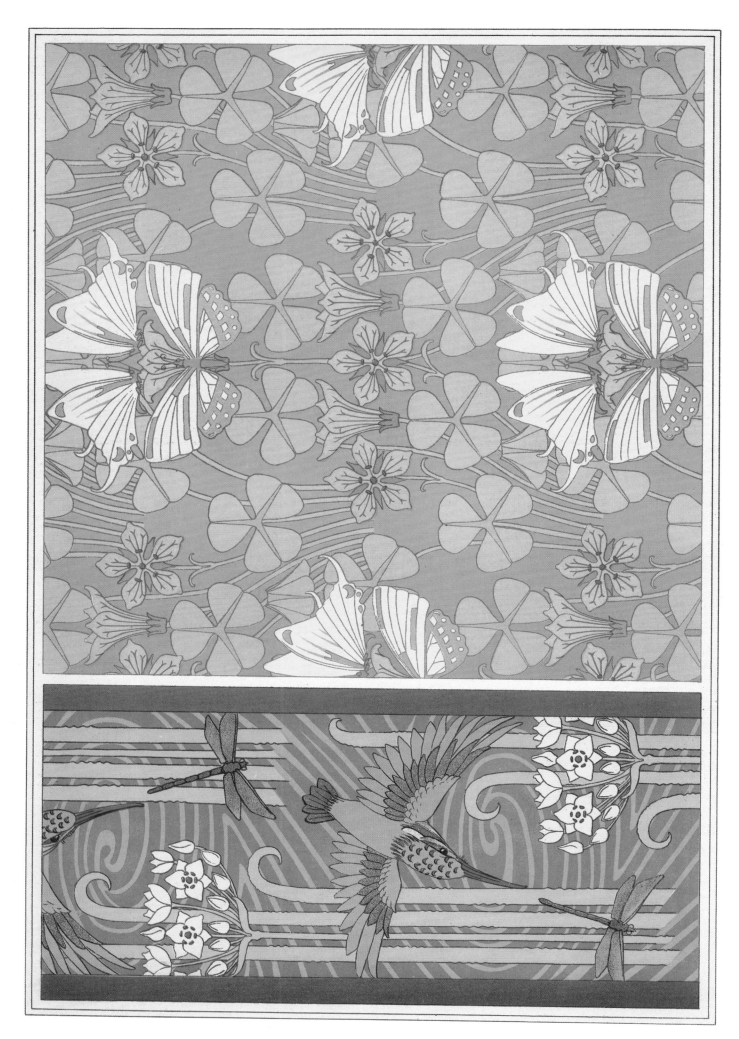

24. Kingfishers, dragonflies and flowering rush; butterflies and wood sorrel.

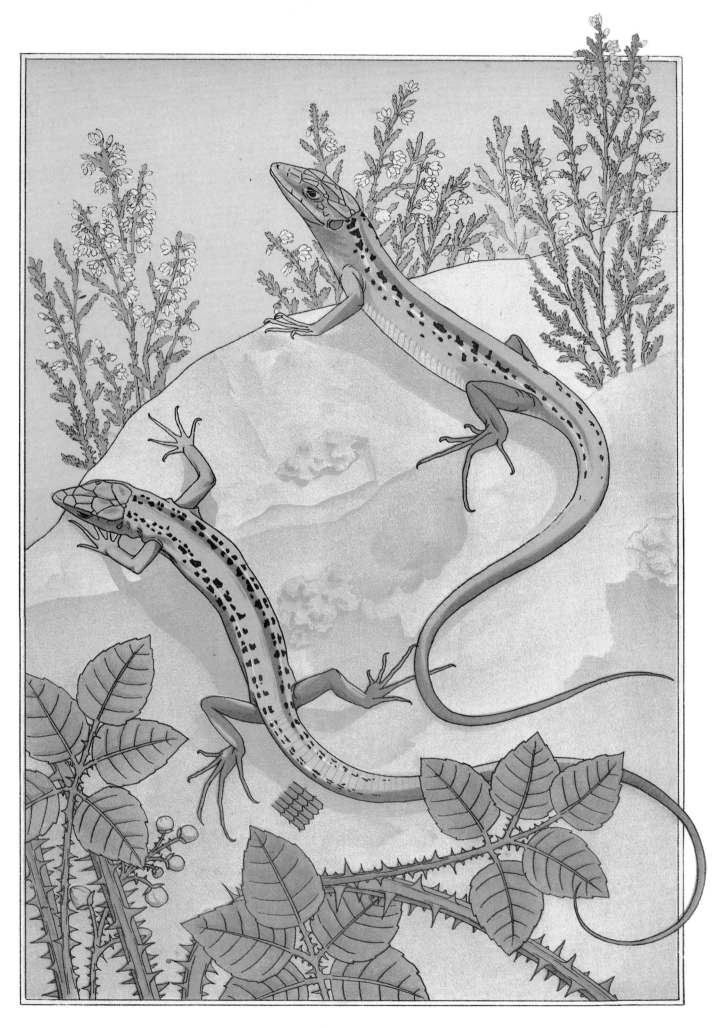

25. Lizards.

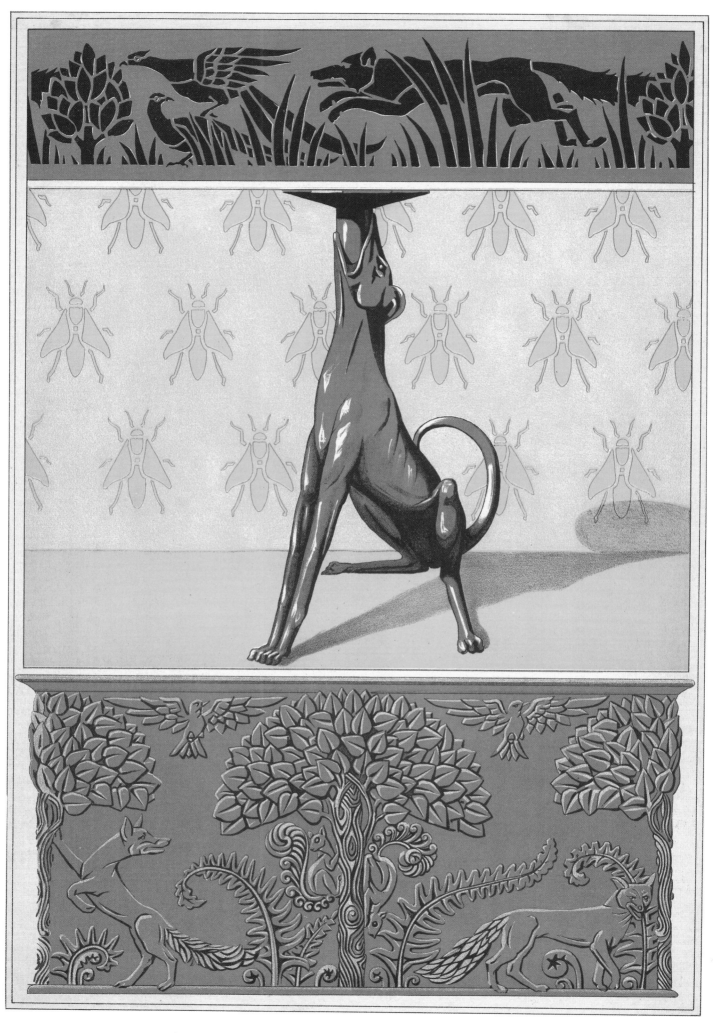

26. Pheasants and fox; dog and bees; foxes, squirrels and birds.

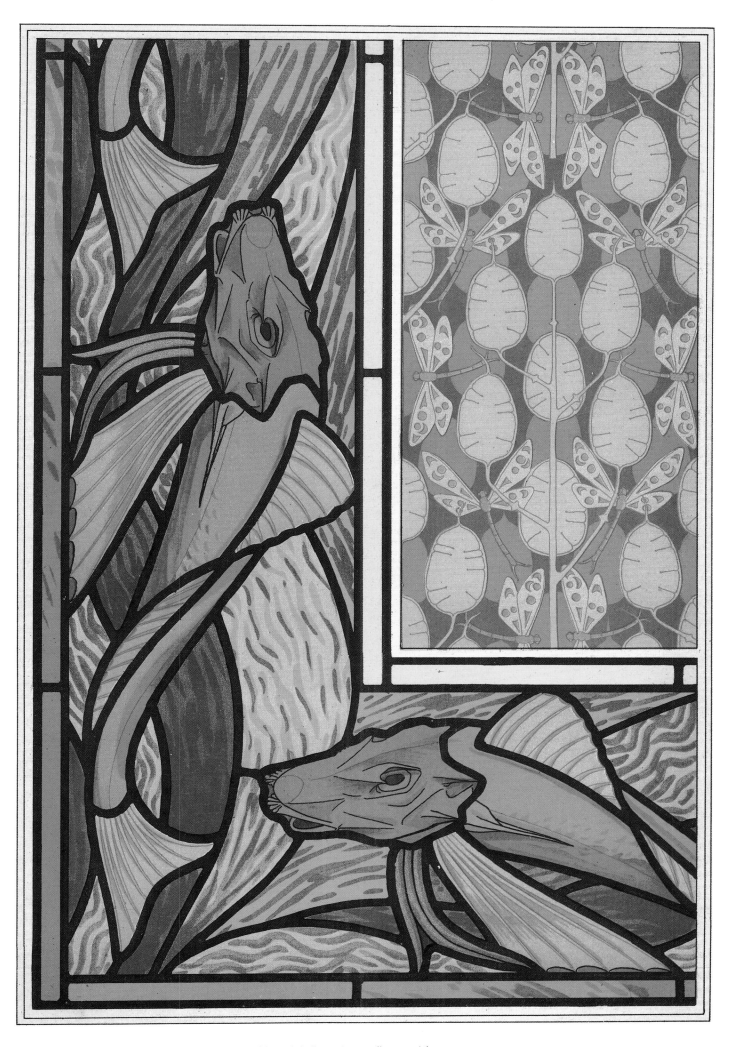

27. Mullet; dragonflies and honesty.

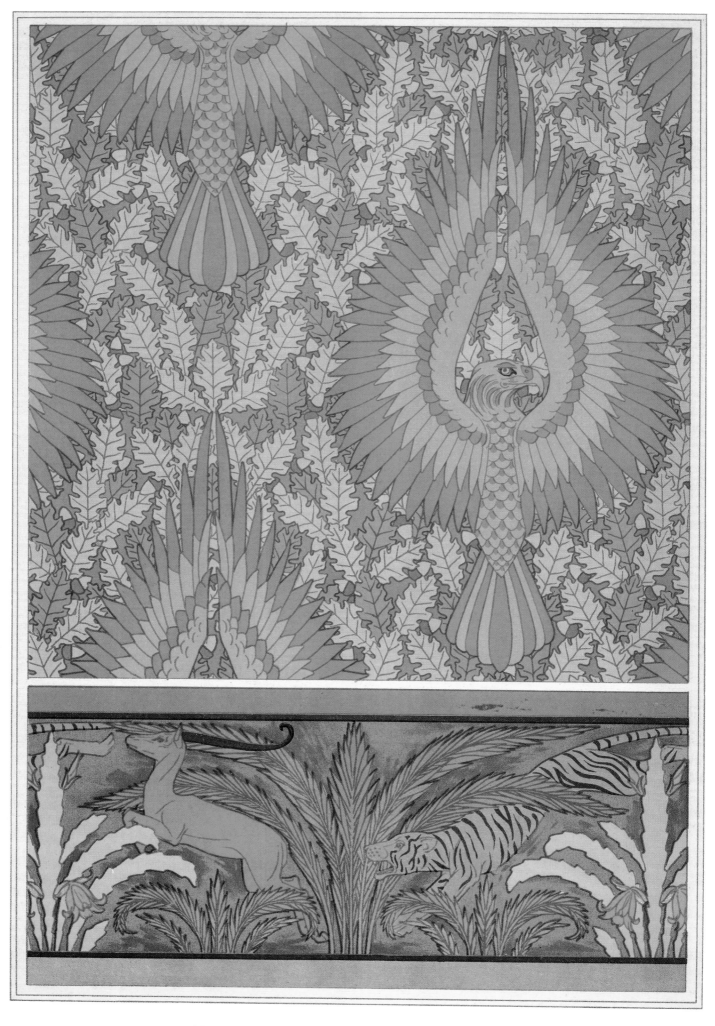

28. Eagles and oak; antelope, tigers, cacti and palm trees.

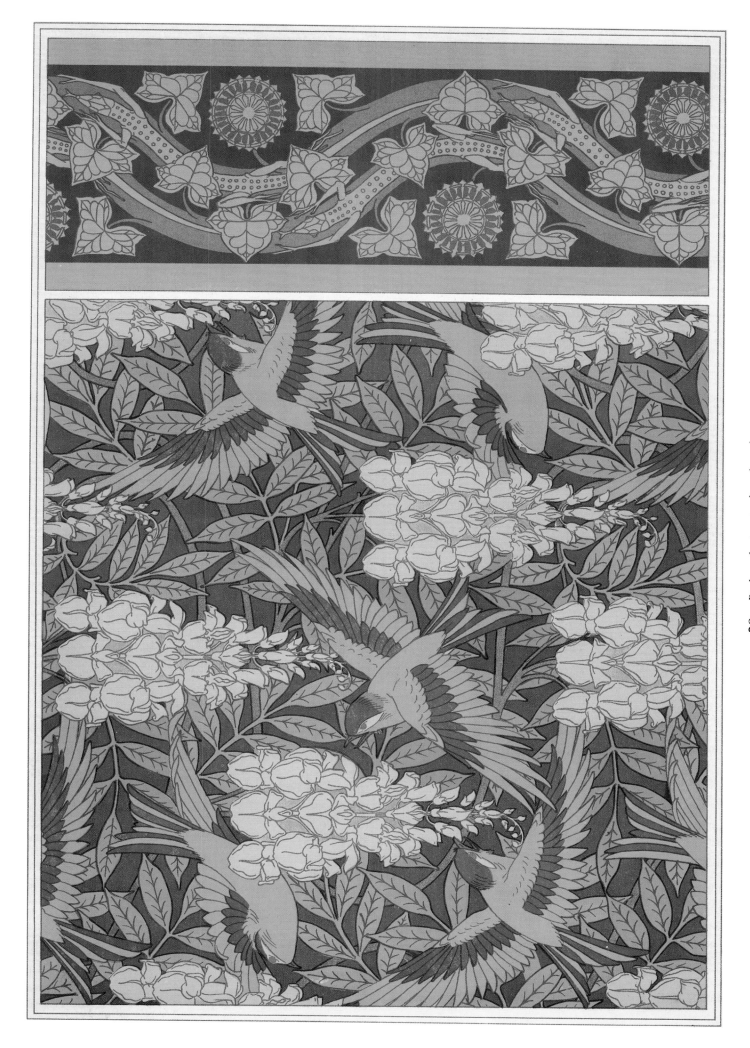

29. Birds and wisteria, lizards and ivy.

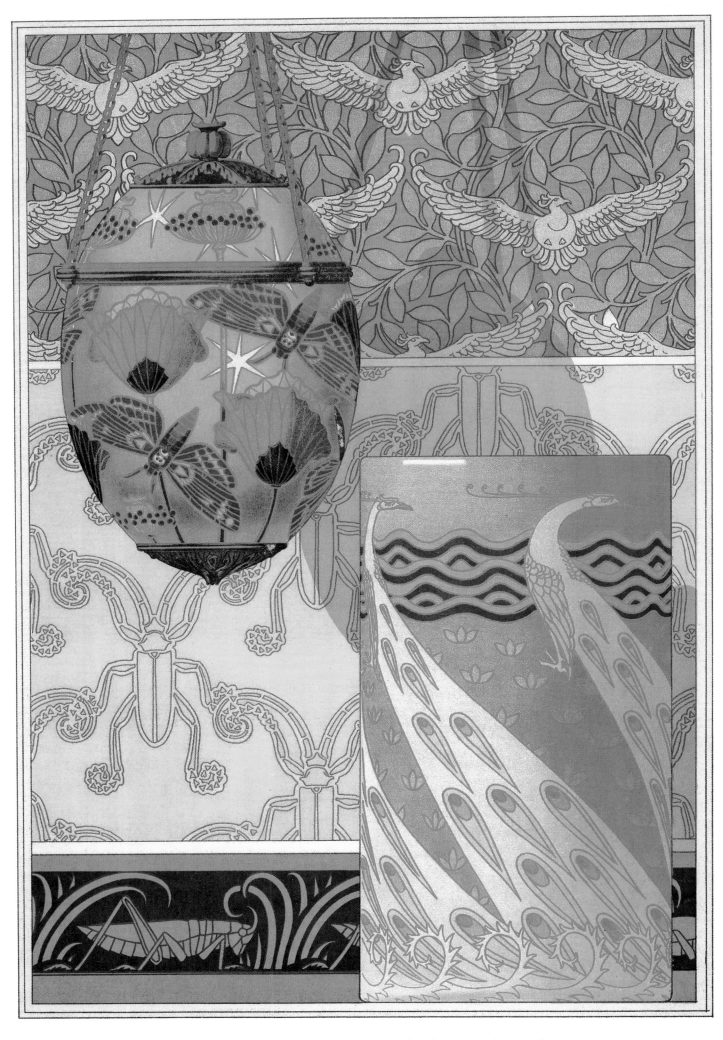

30. Birds; butterflies and poppies; capricorn beetles; peacocks; grasshoppers.

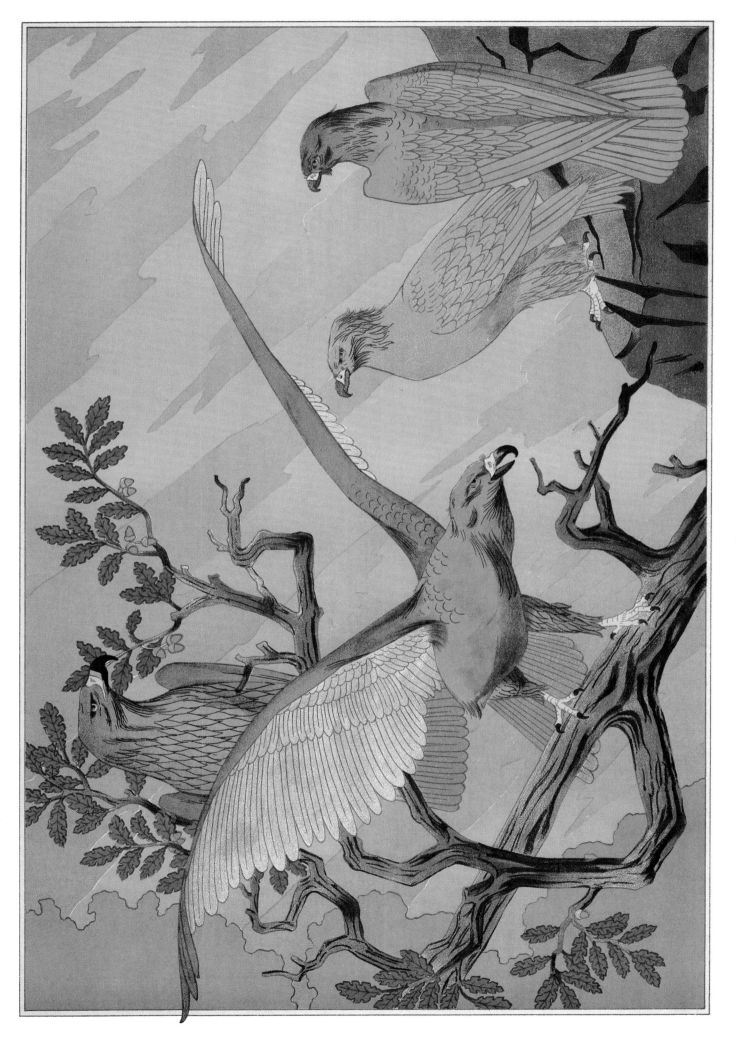

31. Eagles.

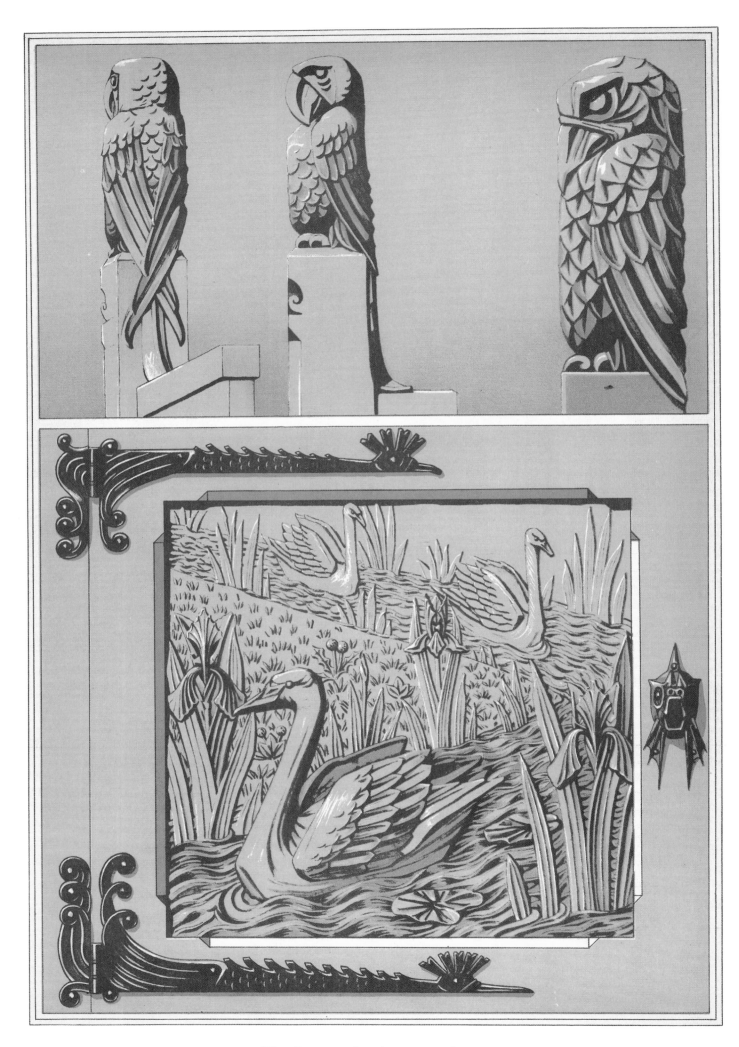

32. Parrots and eagle; swans and irises.

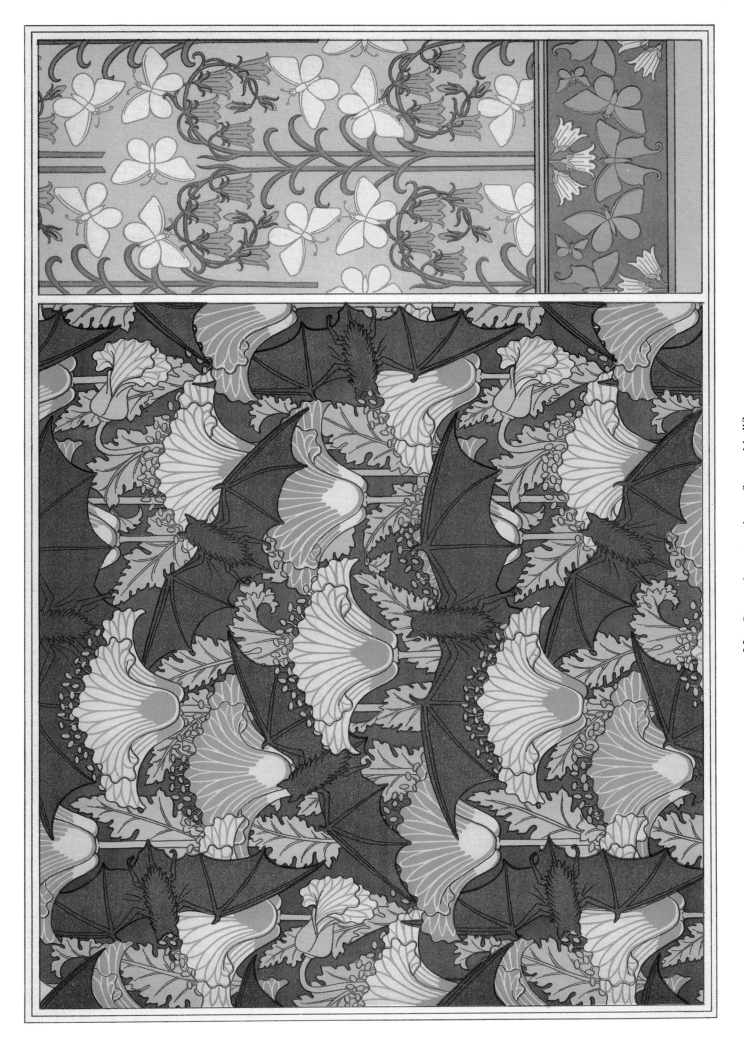

33. Bats and poppies; butterflies and bellflowers.

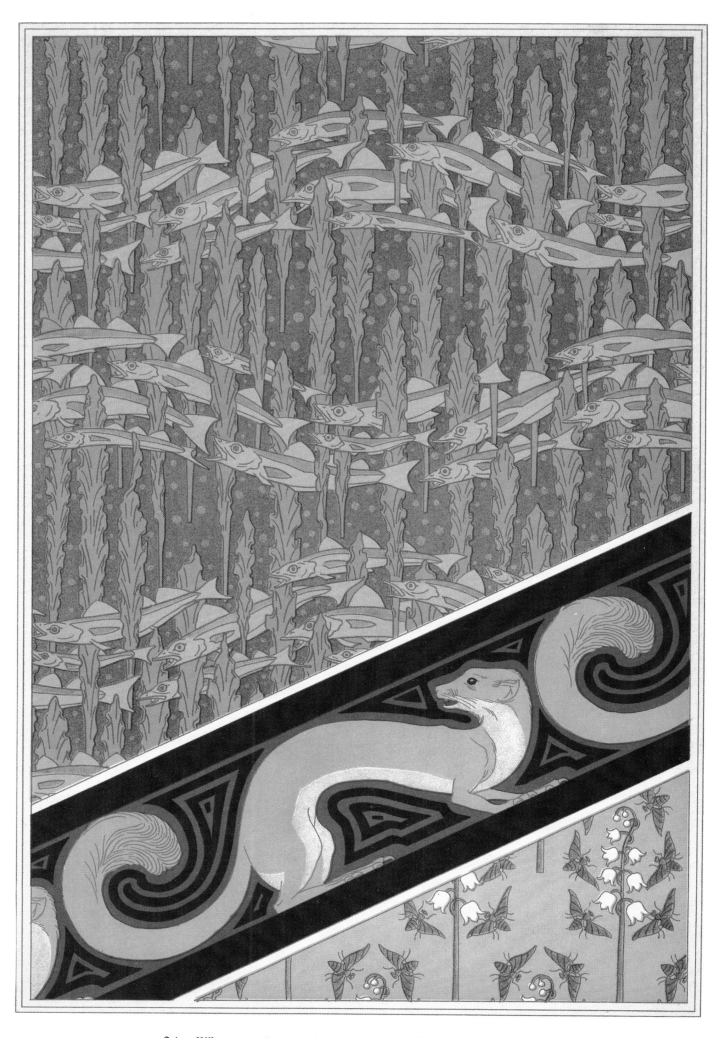

34. Whiting and seaweed; common stoat; flies and lily of the valley.

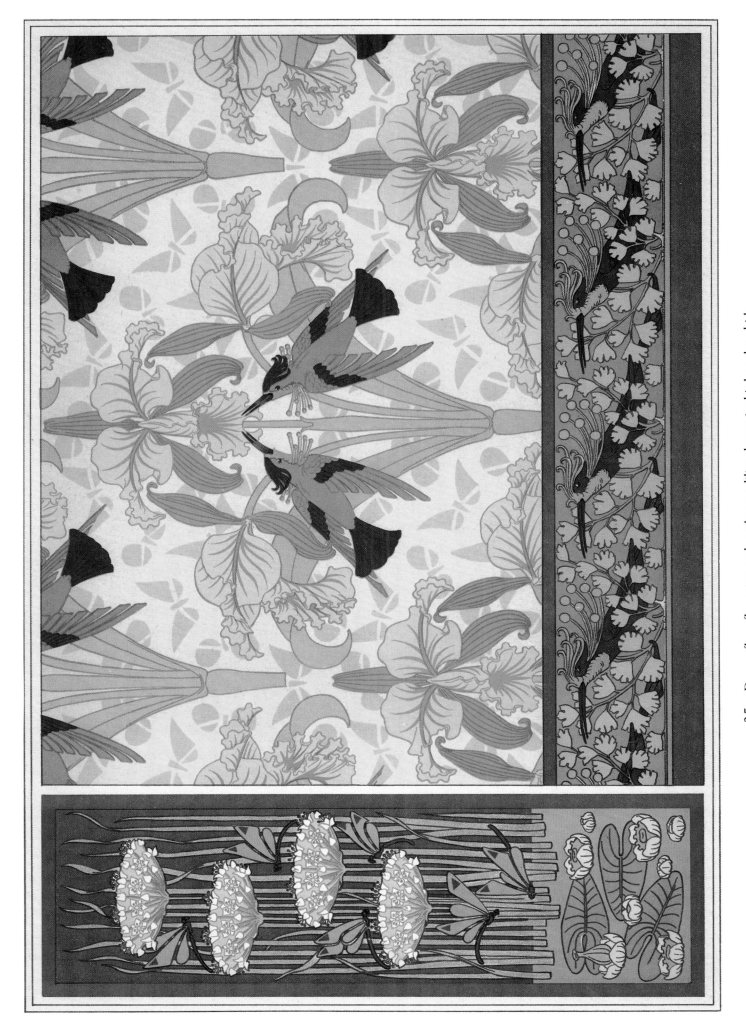

35. Dragonflies, flowering rush and water lilies; hummingbirds and orchids; hummingbirds and maidenhair.

36. Cockatoos; dogs, roe deer and wild boars.

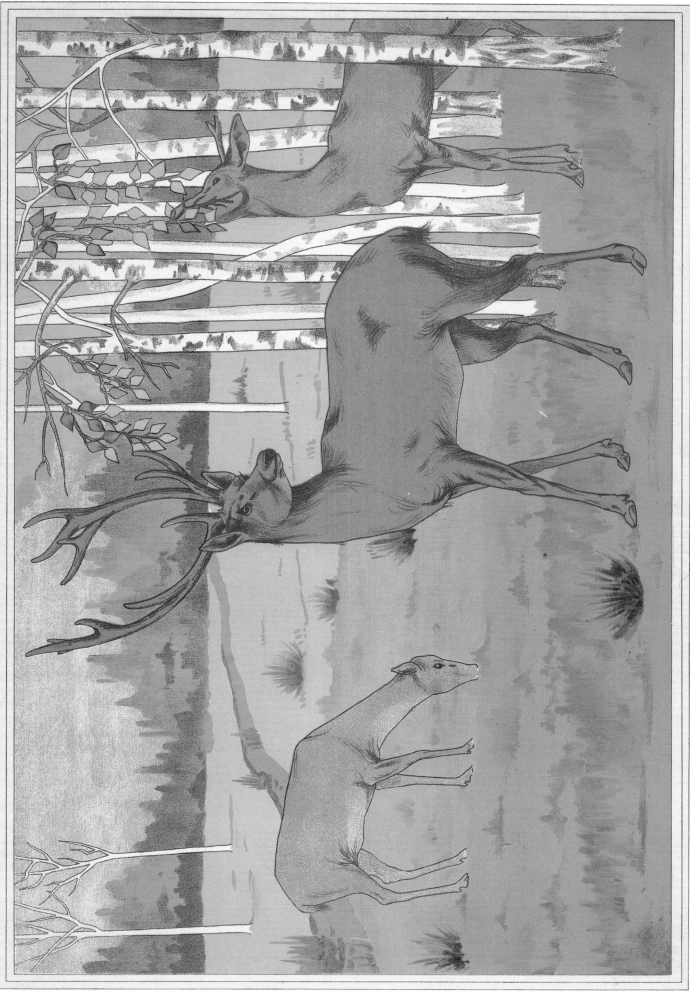

37. Deer.

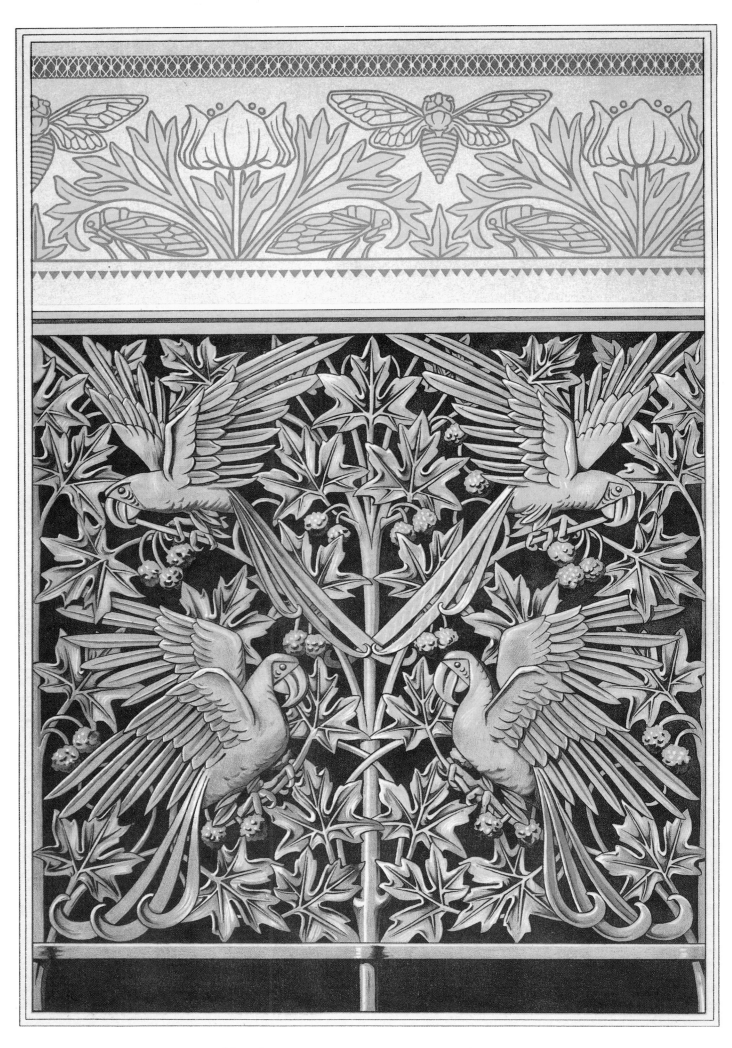

38. Cicadas and anemones; macaws and plane tree.

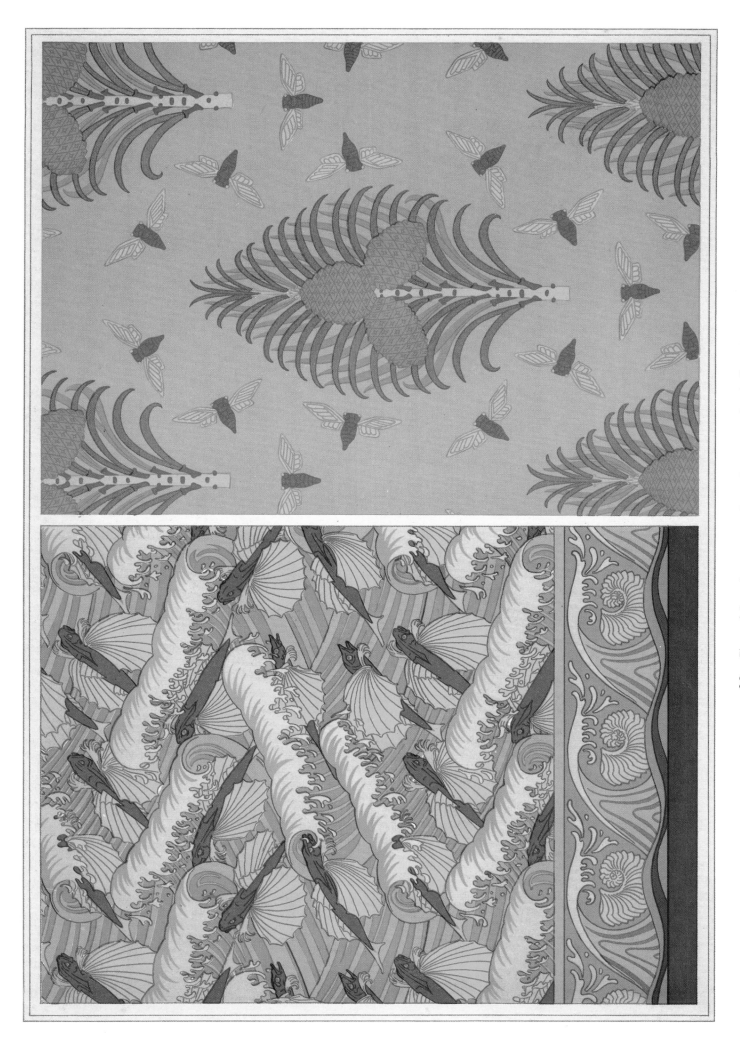

39. Flying fish and waves; cicadas and pine; nautilus shells.

40. Cockatoos and magnolia; white mice.

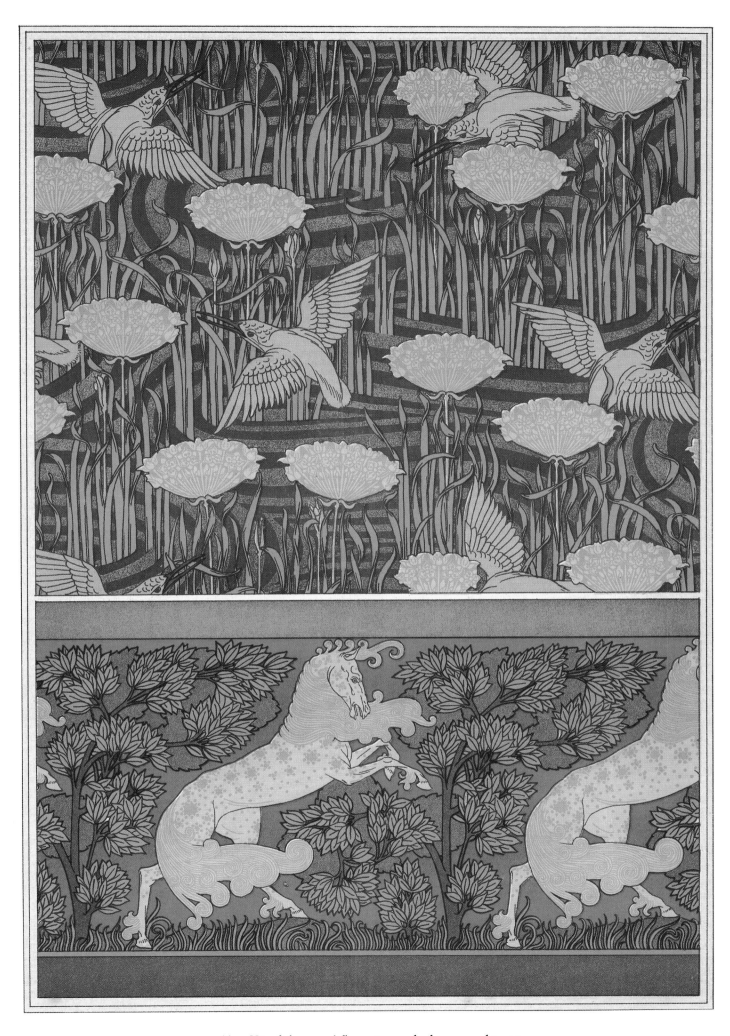

41. Kingfishers and flowering rush; horses and trees.

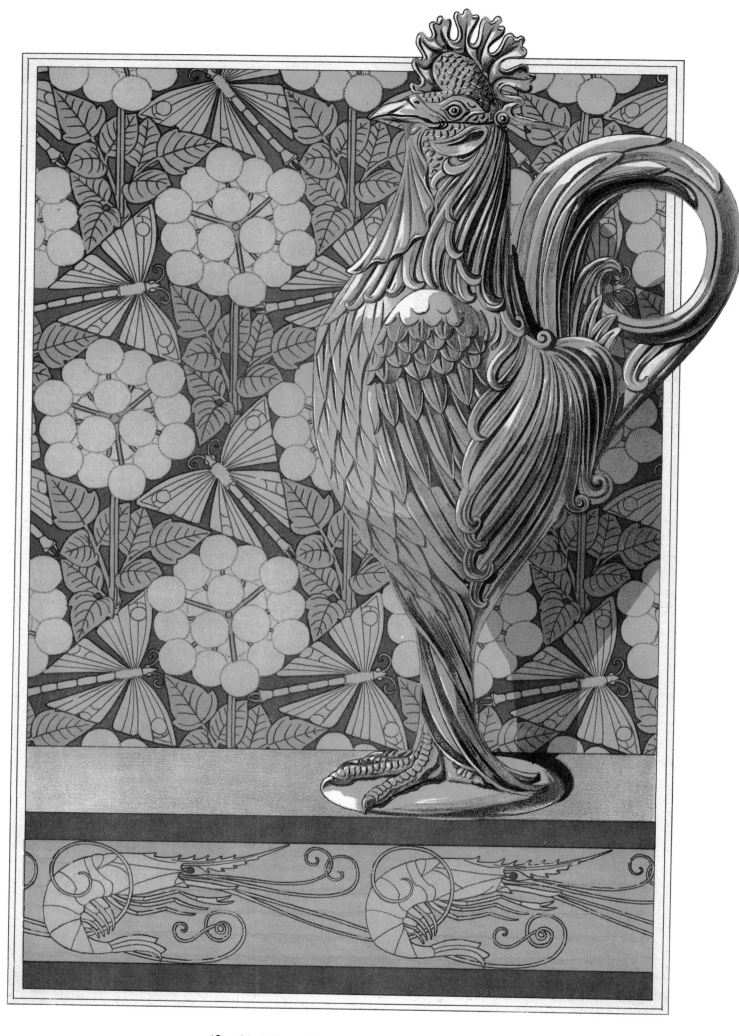

42. Umbels and dragonflies; rooster; shrimps.

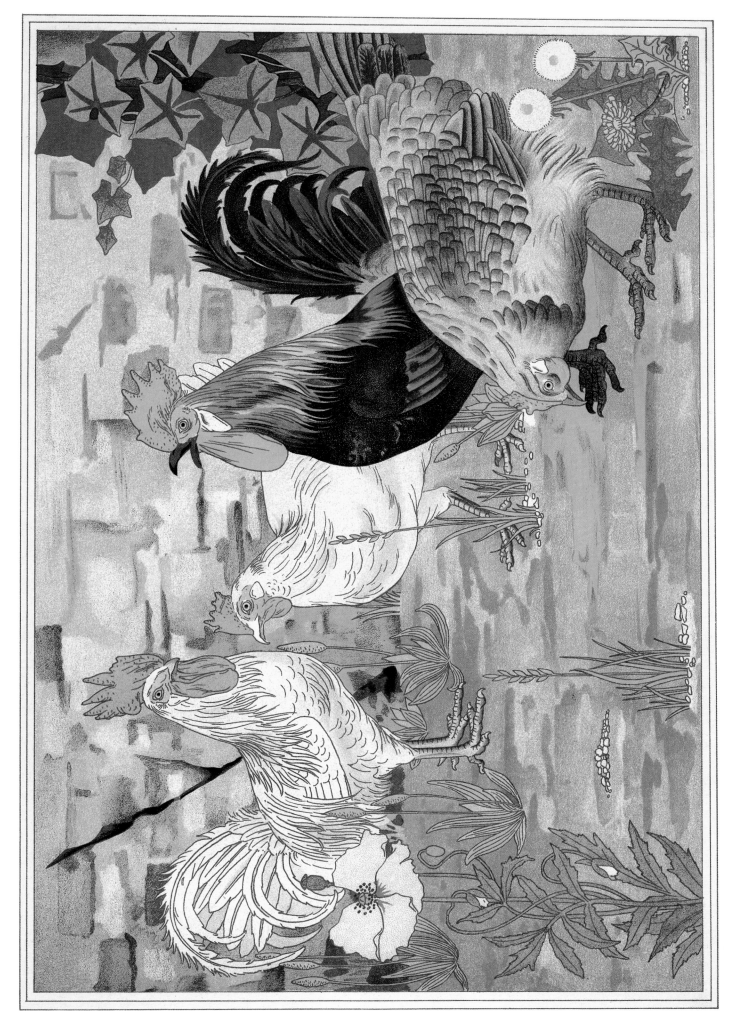

43. Roosters and hens.

44. Lion, ducks and irises; tortoises.

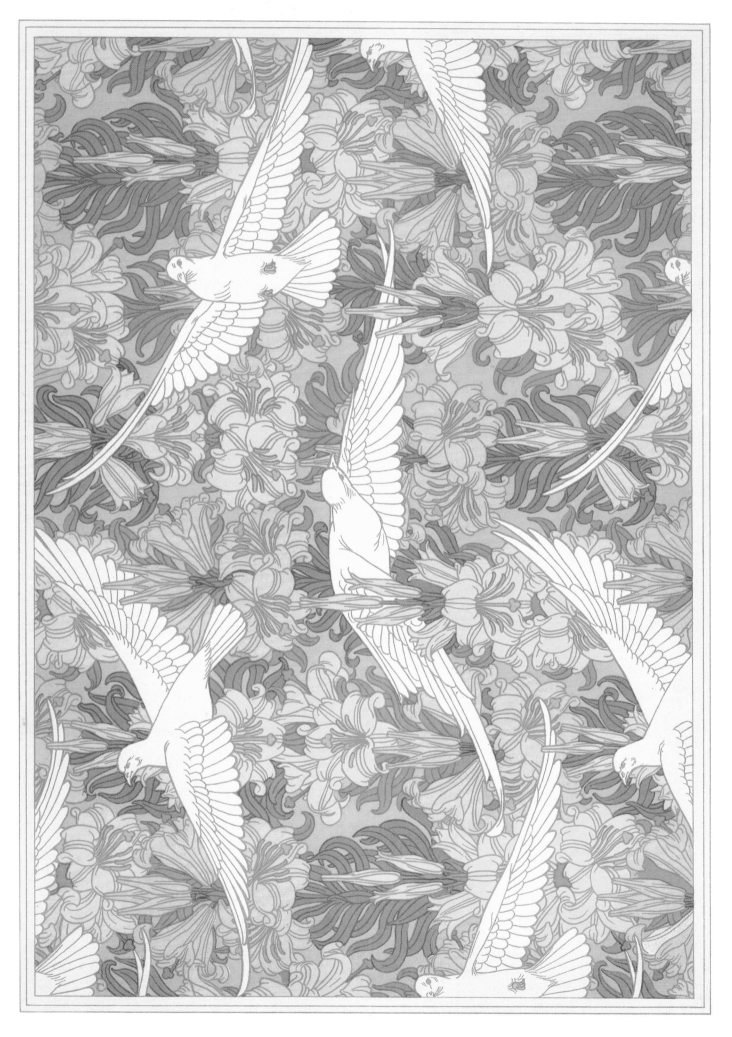

45. Doves and lilies.

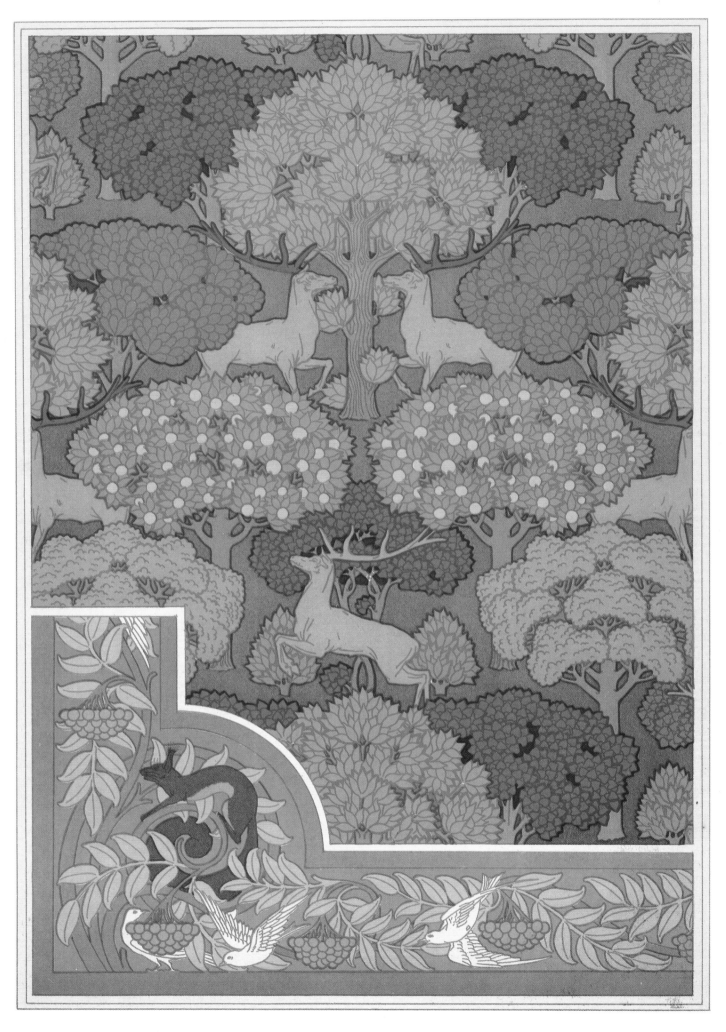

46. Stags and trees; squirrel, birds and sorb.

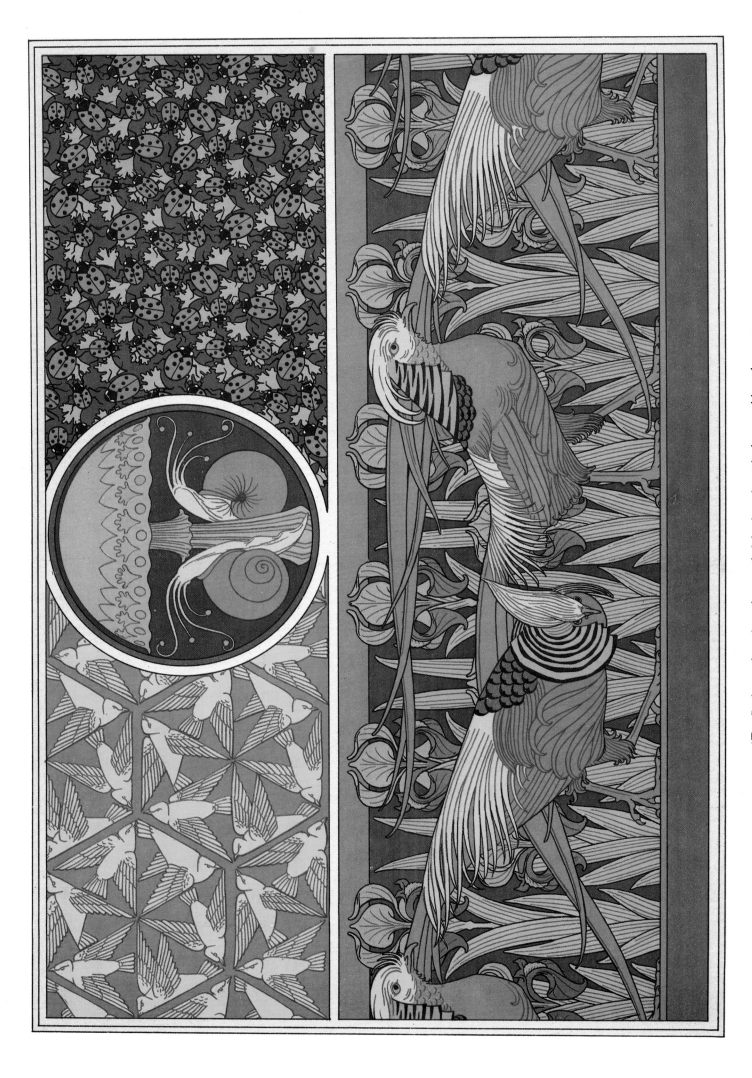

47. Birds; snails and mushroom; ladybirds and maidenhair; golden pheasants and irises.

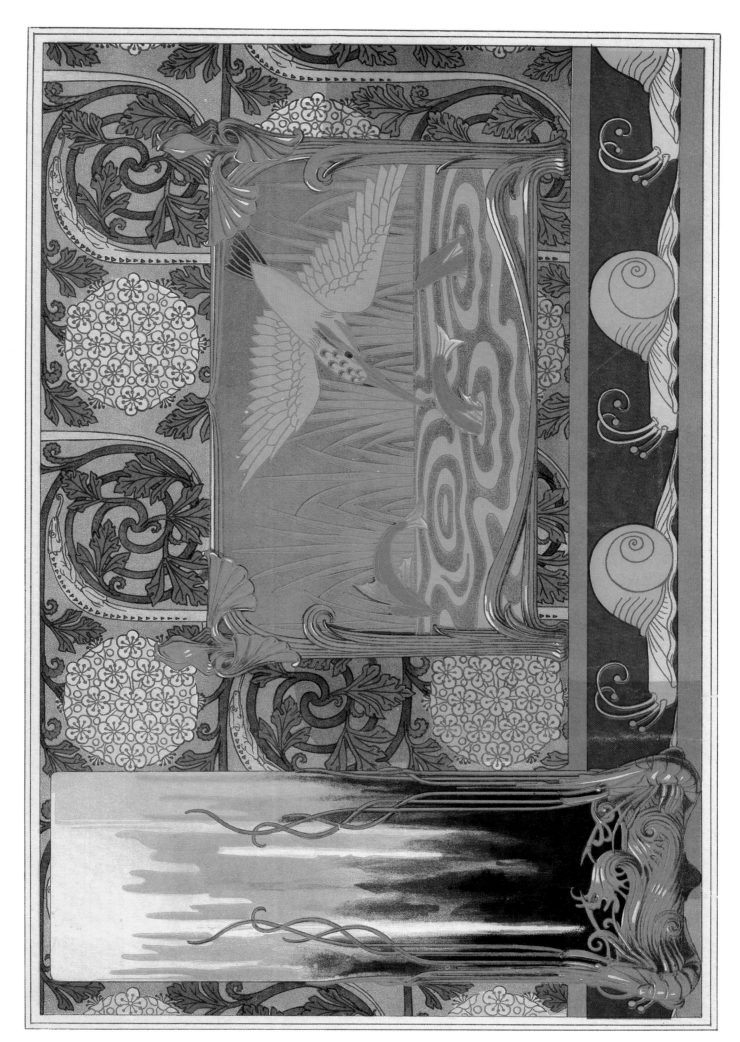

48. Shrimps; lizards and hawthorn; kingfisher and fish; snails.